AISHET HAYIL

אשת חיל

Yeshiva University Museum

**YESHIVA
UNIVERSITY
MUSEUM**

*Yeshiva University Museum
500 West 185th Street
New York, NY 10033-3201*

*ISBN Library of Congress
0-945447-05-1
1993*

FOREWORD

Nothing gives me more pleasure than to be associated with this exhibition. As chairperson of the Museum Board, I always enjoy the opportunity afforded me to view quality work done by women.

I remember Julia Forchheimer, a loving kind friend and teacher. In her field of weaving, she trained a whole generation of students who revered her. I personally benefitted from her immaculate taste which took roots in the Bauhaus tradition. My personal special love for her and her late beloved husband, Leo, make my work in the exhibition a labor of love.

Erica Jesselson
Chairman,
Museum Board of Governors

AISHET HAYIL REVISITED

For three thousand years, the Aishet Hayil has defined the ideal Jewish woman. The full-length portrait that emerges from this description is striking for its power — dynamic, productive, creative, versatile, nurturing, prescient, fearless, humorous, confident. Like the acrostic form it is couched in, the character described is multi-dimensional, from A to Z, from Aleph to Taf.

Since ancient times the evocative lines of this poem have provided images for scholars, illuminators, silversmiths, rabbis, and synagogue leaders. It has been cited, recited, and sung — traditionally on Friday nights after the Kiddush over wine, and most recently at weddings, when the groom and his friends, clasping each other by the shoulders, surround the bride and serenade her.

Because it is the only hymn to a woman in the Biblical writings, it is also frequently — too frequently perhaps — recited at women's funerals, a feature that has not endeared it to many for whom it has become trivialized.

In fact, one of the goals of the exhibition is to compel us to take a second look at the poem — through the eyes of 32 artists — who were invited to choose a line and create an interpretive work — to "envision the field" and then share that vision with us.

The 33 works on display, in an abundance of media, invite us to explore, question, experience, remember, and hopefully admire. We are forced to see beyond the verbiage which may have become too familiar, to encounter anew the immense significance and relevance the Aishet Hayil holds for our post-modern, post-women's movement generation.

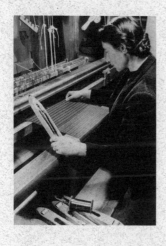

This exhibition was conceived as a tribute to an exceptional woman, Julia Keiner Forchheimer (1900-1991), who opened the handweaving department in the Bezalel School of Arts and Crafts in Jerusalem in 1936. Her biography appears at the back of this book.

We believe that Julia, a modest lady who shunned the limelight all her life, would nevertheless be thrilled by the astonishing artworks her memory has generated. In choosing to commemorate her life with an exhibition, the last lines of the Aishet Hayil were our inspiration,

> GIVE HER FROM THE FRUIT OF HER HANDS,
> AND LET HER BE PRAISED IN THE GATES
> BY HER OWN DEEDS.

And in choosing women as the interpreters, we were inspired by Shakespeare's epigram about one woman,

> AGE CANNOT WITHER, NOR CUSTOM STALE,
> HER INFINITE VARIETY.
> (Antony and Cleopatra II.ii.140)

The exhibition and catalogue were made possible by a generous grant from the Forchheimer Foundation, which also sponsored the renovation of the exhibition gallery. We are exceedingly grateful to the officers of the Foundation for this gift.

Sylvia Axelrod Herskowitz
Curator of the Exhibition

A WOMAN *of* VALOR

A woman of valor, who can find?
 far beyond pearls is her value.
The heart of her husband relies on her, and he shall lack no fortune.
She will do him good and not evil, all the days of her life.
She seeks out wool and flax, and her hands work willingly.
She is like the merchant ships, from afar she brings her sustenance.
She arises while it is yet nighttime, and gives food to her household,
 and a portion to her young women.
She envisions a field, and buys it,
From the fruit of her hands, she plants a vineyard.
With strength she girds her loins, and invigorates her arms.
She discerns that her merchandise is good,
 her candle does not go out by night.
She stretches out her hands to the distaff, and her palms hold the spindle.
She stretches out her palm to the poor,
 and extends her hands to the destitute.
She fears not snow for her household, for all are clothed
 with scarlet wool.
Coverlets she makes, fine linen and purple wool are her clothing.
Distinctive in the councils is her husband,
 when he sits among the elders of the land.
She makes a cloak and sells it, and delivers a belt to the peddler.
Strength and majesty are her clothing, and she laughs at the last day.
She opens her mouth with wisdom, and a lesson of kindness
 is on her tongue.
She looks well to the ways of her household,
 and partakes not of the bread of laziness.
Her children arise and gladden her, her husband and he praises her.
Many daughters have done valiantly, but you surpass them all.
Grace is deceitful and beauty vain, a woman who fears God,
 she should be praised.
Give her from the fruit of her hands, and let her be praised in the gates
 by her own deeds.

CALLIGRAPHY BY LYNN BROIDE

A WOMAN OF VALOR

WHO CAN FIND?

FAR BEYOND PEARLS

IS HER VALUE.

אשת־חיל מי ימצא

ורחוק מפנינים מכרה׃

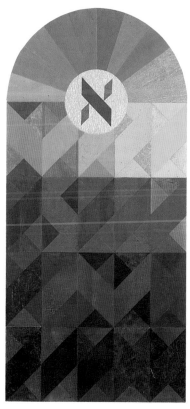

Photo: James Dee

ALEPH, SIRI BERG

Collage
Japanese Wood Block Prints on Arches, Japanese, and Tyvek Papers
30" x 56"

The artist bases her composition on the Kabbalistic explanation that Aleph — the first
letter of the Hebrew alphabet — is composed of other Hebrew letters: two yuds, for the
two faces of reality, and a vav, the force that joins them together. The colors of pearl,
scarlet, and purple refer back to the poem.

THE HEART OF HER HUSBAND

TRUSTS IN HER

AND HE SHALL

LACK NO FORTUNE.

בטח בה לב בעלה

ושלל לא יחסר:

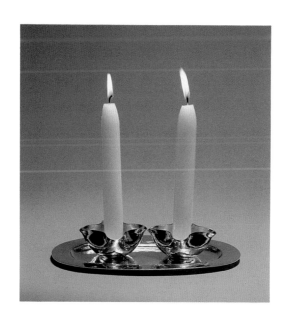

SHABBAT CANDLE HOLDERS AND TRAY
MALKA COHAVI

Silver
Candle Holders: 3 1/4" x 2"
Tray: 11" x 7"

SHE WILL DO HIM GOOD

AND NOT EVIL,

ALL THE DAYS OF HER LIFE.

גמלתהו טוב ולא־רע

כל ימי חייה:

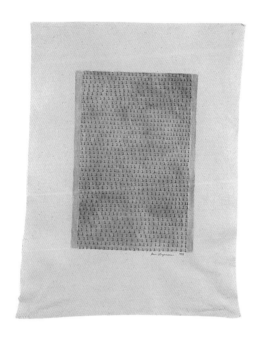

Untitled 1993, Jane Logemann

Painting, Oil, ink, and varnish on canvas
10 1/2" x 7 1/2"

The artist uses individual letters of the alphabet (here the Hebrew letter gimmel) as a visual abstract, which she repeats in rows to elicit a literal, associative, and purely visual reaction.

ד

SHE SEEKS OUT

WOOL AND FLAX

AND HER HANDS

WORK WILLINGLY.

דרשה צמר ופשתים

ותעש בחפץ כפיה:

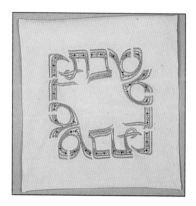

HALLAH COVER, MENUCHAH DEUTSCH

Silk embroidered with gold and silk thread; pearls, semi-precious stones in gold settings, 16"x 17"

Inscribed in Hebrew: "Holy Sabbath"

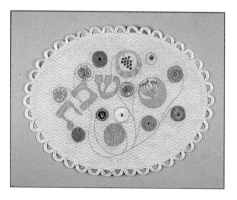

HALLAH COVER, ESTER JESSELSON

(gift to a mother-in-law from a daughter-in-law)
Silk embroidered with metallic threads; semi-precious stones 23" x 18"

Inscribed in Hebrew: "Sabbath"

SHE IS LIKE

THE MERCHANT SHIPS,

FROM AFAR SHE BRINGS

HER SUSTENANCE.

היתה כאניות סוחר

ממרחק תביא לחמה:

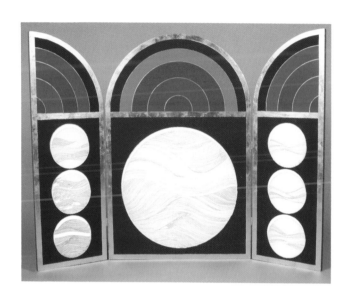

TRIPTYPCH, SUSAN SCHWALB

Silverpoint, gold leaf, and acrylic on wood
32" x 36" x 10"

The artist, who has worked extensively with water imagery based on the Creation illuminations in the Sarajevo Haggadah (14th century), expands on those images and enshrines them.

S HE ARISES WHILE

IT IS YET NIGHTTIME,

ותקם בעוד לילה

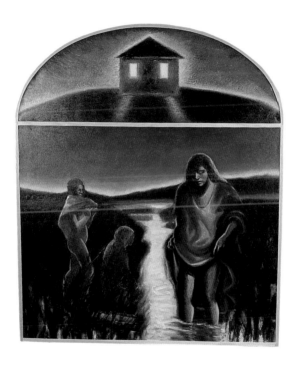

Painting, Janet Shafner

Oil on linen
53" x 62"

The artist draws on rabbinic commentary which interprets this phrase as alluding to Batya, the righteous daughter of Pharaoh, who went down to the Nile before dawn, discovered Moses floating in the basket and saved him.

AND GIVES FOOD

TO HER HOUSEHOLD

AND A PORTION

TO HER YOUNG WOMEN.

ותתן טרף לביתה וחק לנערתיה׃

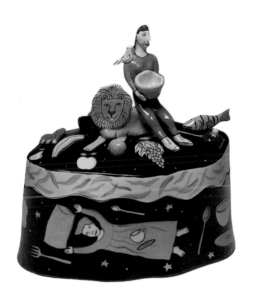

THE BOX OF NOURISHMENT,
SUSAN GARSON AND TOM PAKELE

Ceramic vessel,
White earthenware; underglazes
8 1/2" x 9"

The inside shows a woman eating a pear.

S HE ENVISIONS A FIELD

AND BUYS IT,

זממה שדה ותקחהו

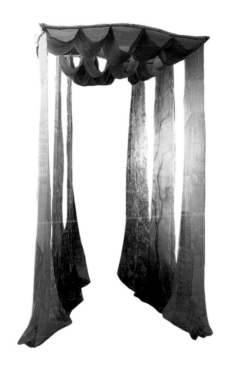

HEAVEN AND EARTH — A VISION
CORINNE SOIKIN STRAUSS

Painted silk organza; wood branches
4'x 5'x 7'

First a huppah, then an arbor, and finally a Sukkah seemed to emerge as the artist sought to give shape and substance to the vision of a golden field in which a woman plants a vineyard.

F<small>ROM THE FRUIT</small>

O<small>F HER HANDS</small>

S<small>HE PLANTS A VINEYARD.</small>

מִפְּרִי כַפֶּיהָ נָטְעָה כָּרֶם:

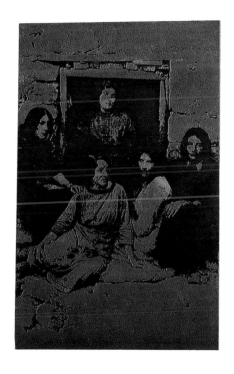

BUILDING WORKERS
(AT THE MIGDAL SETTLEMENT, 1935)
GABI SALZBERGER

Photo etching, oxidized steel
15 3/4" x 10 1/4" x 2 3/4"

The artist uses historic images of Zionist pioneers printed on rusting steel
to make her statement

WITH STRENGTH

SHE GIRDS HER LOINS,

AND INVIGORATES

HER ARMS.

חגרה בעוז מתניה

ותאמץ זרועותיה:

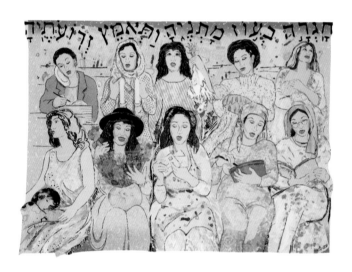

Tapestry, Bat Zvi

Fabric Collage
48" x 64"

The different characters depicted in this artist's tapestry represent the multi-faceted Woman of Valor of our time. In using fabric collage tapestry as her medium, the artist pays tribute to women, who for thousands of years used fabrics in the course of their daily lives.

SHE DISCERNS THAT

HER MERCHANDISE IS GOOD,

טעמה כי־טוב סחרה

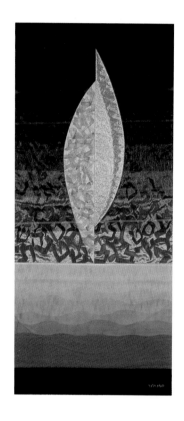

Wall hanging, Chagit Zeltzer

Applique
21" x 45"

The artist refers to the great medieval commentator, Rashi, who compares
the Woman of Valor to the Light of the Torah. The styles of the Hebrew
letters refer to three significant periods in Jewish history and are taken
from the Dead Sea Scrolls (1st century, C.E.), the Sarajevo Haggadah
(14th century), and the Damascus Keter (10th century)

So HER LAMP

IS NOT SNUFFED OUT

BY NIGHT.

לֹא־יִכְבֶּה בַלַּיְלָה נֵרָהּ׃

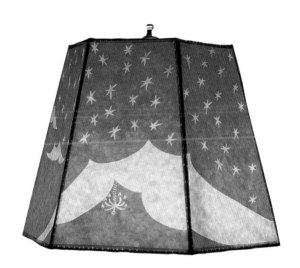

LAMPSHADE,
MARTIN AND JOAN BENJAMIN-FARREN

Papercut: Arches paper on parchment paper; satin ribbon

10 1/2" x 9"

In this work, the 93 stars in the sky symbolize the 93 Bet Yaakov girls who martyred themselves rather than submitting to Nazi abuse; the large tent refers to that of Sarah and Rebekah, whose lamps within burned from Sabbath to Sabbath.

 S HE STRETCHES OUT

HER HANDS TO THE DISTAFF,

AND HER PALMS

HOLD THE SPINDLE.

ידיה שלחה בכישור

וכפיה תמכו פלך:

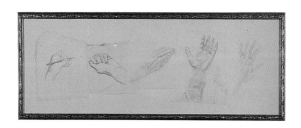

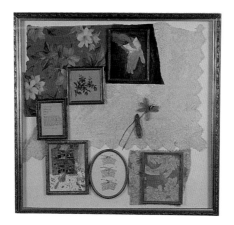

The Work of Our Hands
Judith Cohen Margolis

Top: Pencil on paper
23" x 56"

Bottom: Gouache on paper, crochet work by Magda Baumgart, needlepoint, silk
brocade, beadwork by Carrie Baumgart Cohen, found objects, collage.
46" x 46"

SHE STRETCHES

OUT HER PALM

TO THE POOR,

כפה פרשה לעני

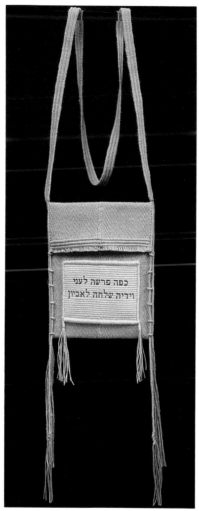

TZEDAKAH POCKET, LAURIE GROSS

Weaving,
Linen
8" x 8" x 27 1/2"

To facilitate the giving of charity (tzedakah) the artist creates a new ritual object — a portable pocket — dedicated to the memory of her aunt, recalling her acts of kindness to strangers

AND EXTENDS

HER HANDS

TO THE DESTITUTE.

וְיָדֶיהָ שִׁלְּחָה לָאֶבְיוֹן:

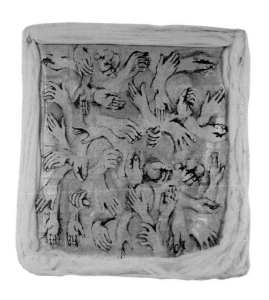

THE DISTAFF SIDE, CHANA CROMER

Assemblage
Acrylic on canvas; raw wool, metallic threads, found objects
40" x 40"

The artist dedicates this work to her mother-in-law, a small woman whose hands were larger than life, always ready to do handiwork and acts of kindness.

SHE FEARS NOT SNOW

FOR HER HOUSEHOLD,

FOR ALL ARE CLOTHED

WITH SCARLET WOOL.

לֹא־תִירָא לְבֵיתָהּ מִשָּׁלֶג

כִּי כָל־בֵּיתָהּ לָבֻשׁ שָׁנִים׃

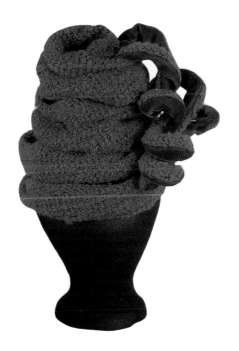

EMBODIMENT, ELAINE PERLOV

Hat
Wool and velvet on galvanized steel frame
9 1/2" x 7 1/2"

This headpiece for the Aishet Hayil reflects her inner strength and elegance; its tall cone shape channels the energy from just above her eyes to the uppermost coil.

Coverlets she makes,

FINE LINEN AND PURPLE WOOL

ARE HER CLOTHING.

מַרְבַדִּים עָשְׂתָה־לָּהּ

שֵׁשׁ וְאַרְגָּמָן לְבוּשָׁהּ:

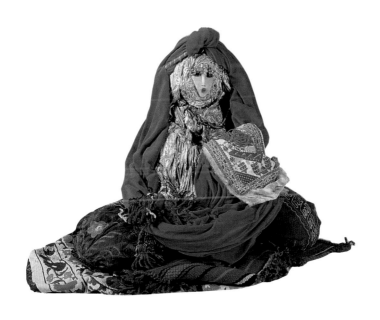

SEATED FIGURE OF A WEAVER
NOEMI SAREL

Plasticene; metallic paint, embroidered cotton, velvet, metal jewelry

22" x 18"

Distinctive in the councils

is her husband,

when he sits among

the elders of the land.

נודע בשערים בעלה

בשבתו עם זקני־ארץ:

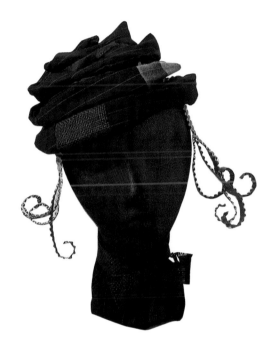

PUBLIC FACE / PRIVATE SELF
ELAINE PERLOV

Hat: Wool, cotton, and burlap on galvanized steel.

5" x 8"

This hat for Aishet Hayil's husband combines wool pinstripe and satin with rough burlap and flannel to show his dual role as community leader and breadwinner.

SHE MAKES

A CLOAK AND SELLS IT,

AND DELIVERS A BELT

TO THE PEDDLER.

סדין עשתה ותמכר

וחגור נתנה לכנעני:

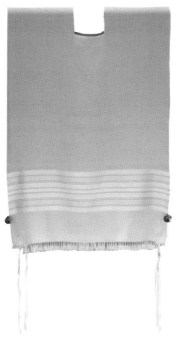

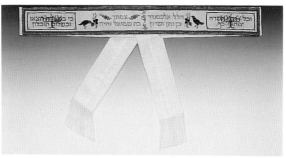

WEDDING KITTEL AND BELT
SHARON NORRY

Garment: handwoven wool, silk, metallic thread; vermeil bells with garnets
30" x 50"
Belt: silk and metallic thread worked on silk canvas
3 1/2" x 32"

Inscribed in Hebrew: "And all the trees in the field will applaud. Groom,
Hillel Alexander son of Natan and Sharon. Bride, Esther, daughter of Shmuel
and Haya. Ellul 1,5752. You shall go out with joy and be led forth in peace."

Strength and majesty

are her clothing,

עוז־והדר לבושה

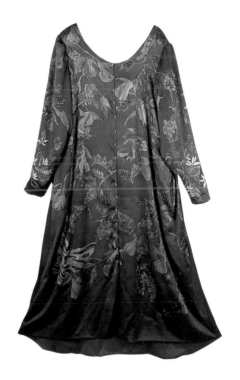

AN ABUNDANCE OF SPIRIT, ELLEN EICHEL

Robe: painted silk charmeuse
60" x 60"

This long flowing robe worn close to the body, decorated with imagery of edible plants and insects, represents the ideal woman's complete personal knowledge and acceptance of the natural world.

A{.sc}ND SHE LAUGHS

AT THE LAST DAY.

ותשׂחק ליום אחרון:

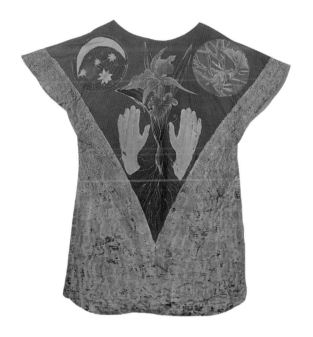

An abundance of Spirit, Ellen Eichel

Tunic: Painted silk taffeta, beads, metallic cord
40" x 37"

This outer garment is more formed and armor-like, relating to her position in the world, as well as her strength and importance in the universe.

SHE OPENS HER MOUTH

WITH WISDOM,

AND A LESSON OF KINDNESS

IS ON HER TONGUE.

פִּיהָ פָּתְחָה בְחָכְמָה

וְתוֹרַת־חֶסֶד עַל־לְשׁוֹנָהּ:

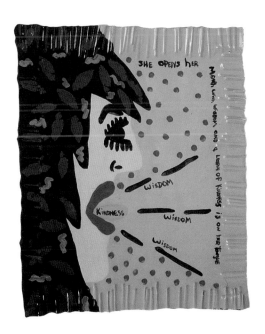

UNTITLED, JERILYNN BABROFF

Ceramic Wall Piece: white clay; underglazes
14 1/2" x 17 1/4"

A whimsical interpretation of the actual phrase.

Biblical
verses are like the
manna that the children of
Israel ate in the desert: one takes
from them what one wants and what is
wanting. The variety of meanings found in
each word of each verse confirms the com-
ment of our sages,"There are seventy aspects to
the Torah," shivim panim la-Torah. Each artist offers
a distinctive interpretation of a verse from the Aishet
Hayil poem through painting, ceramics, photography,
paper-cutting, weaving — the rich possibilities of human cre-
ativity. This essay is an interpretation of the Aishet Hayil
poem that examines, in words, images of a circle and com-
pleteness, and reaches conclusions about the meaning of a life.

A woman's work may never be done but for the Aishet Hayil, the
valiant wife described in the 22-verse acrostic at the end of
Proverbs, a woman's work is complete. Each activity that she
begins — in textiles, in farming, in real estate, in caring for family, for
co-workers, for the poor — she follows through to its culmination.

If she "seeks out wool and flax" (verse 13), six verses further on she
"stretches out her hand to the distaff" (the staff that holds the fiber
while spinning) and "her palms hold the spindle." Her handiwork is so
well done that she does not have to worry about being warm in the
winter: "She fears not snow for her household for her entire house-
hold is clothed in scarlet wool" (21). Not only will everyone be pro-
tected, there will be "coverlets" and clothing of "linen and purple
wool" (22). There will be enough to make "a cloak to sell," and to
"deliver a girdle to the Canaanite" (24), who could be a merchant or
a poor person to whom she gives a gift.

The clothing that defines the Aishet Hayil, however, is neither
wool nor linen, scarlet nor purple. "Strength and majesty are
her clothing" (25) and with these she can approach some-
thing more challenging than the rigors of winter; she can
greet even "the last day" with joy.

In another cycle that comes round to completion, the
Aishet Hayil brings food from afar (14), sustains
everyone in her care (15), estimates the value
of a field, buys it, then plants a vineyard
using the profits from "the fruits of her
hands" (16). In the final verse, the
highest award one
can present to her is
"the fruits of

AISHET HAYIL
A Contemporary Commentary

hands";
no accolade from
another can equal the
inner delight in the completion of
one's own work. Today, when much
of our wealth and achievement is on paper
and few of us create things, it is refreshing to
consider making something (clothing, a food, a
wine, an object of any kind) from start to finish.

The Aishet Hayil's relationships with her husband, chil-
dren, and all who work with her are suffused with trust (11),
kindness, and care for the less fortunate. The same "palms"
and "hands" that produce financial and spiritual "fruit" in verses
16 and 31, and that reach out to spin in verse 19, are extended to
the "poor" and "destitute" in verse 20. There is a circle of gathering
in and giving out: taking in the raw materials for textiles or food, giv-
ing out clothing and sustenance. Her family is the center from which
she moves out to all her interests and activities. She starts from her
husband's trust (11) and comes back to her children's and husband's
praise (28). The husband and wife have significant independent roles,
yet the arcs of their lives join: he is "known in the gates" (23) and "her
deeds praise her in the gates" (31).

The Aishet Hayil does everything with "wisdom" and "kindness" (26),
energy and forethought (27). Women of every age can identify with the
fact that to do so much so well (running a textile-manufacturing concern,
a vineyard, a real estate business, while caring for a large household
and being a genuinely helpful philanthropist)means cutting down on
one's sleep. Day and night come close to being an unbroken circle,
when the Aishet Hayil "gets up while it is yet night" (15) and "her can-
dle does not go out by night" (18).

Every letter of the Hebrew alphabet is present in this acrostic. Just
as the Aishet Hayil brings all her activities to completion, so too
the praise of the Aishet Hayil is brought to completion, encom-
passing the entire alef-bet. The praise of the Aishet Hayil,
because she is a mortal, can be summed up. The alpha-
betic praise of God is infinite and can never be recited in
its entirety. The Psalms end on an imperative note to
all generations: Hallelu-kah! "Praise God!" For the
Aishet Hayil the final words are vi-
halleluhah...ma-aseha: although she is lim-
ited by the boundaries of human
life, "let her deeds" remain.
to"praise her."

RIVKAH TEITZ BLAU
ELISHEVA RABINOVITZ TEITZ

1993

SHE LOOKS WELL TO

THE WAYS OF HER HOUSEHOLD,

AND PARTAKES NOT OF

THE BREAD OF LAZINESS.

צוֹפִיָּה הֲלִיכוֹת בֵּיתָהּ

וְלֶחֶם עַצְלוּת לֹא תֹאכֵל:

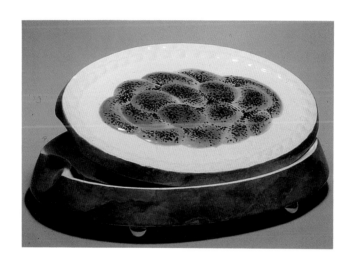

HALLAH TRAY

Glazed porcelain; silver-plated brass ball feet
3 3/4" x 15"

This tray puts Hallah on a pedestal worthy of its ceremonial place in the
Sabbath ritual.

Her children arise

and gladden her,

Her husband,

and he praises her.

קָמוּ בָנֶיהָ וַיְאַשְּׁרוּהָ

בַּעְלָהּ וַיְהַלְלָהּ:

DRAWING, TOVA KATZ
Pencil and marker on paper
18" x 24"

The young artist (age 9) pictures a parade of mothers coming down the aisle,
flanked by cheering husbands and children.

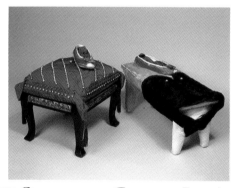

THE STEPPED ON GEMARA, ITA ABER
Footstools: Wooden milking stools; painted muslin, applique, velvet, gold beads
Slippers: satin with metallic ribbon
15" x 14" x 16"

23" x 10" x 15 1/2"

The Gemara tells the story of Rabbi Tarfon, who wanted to honor his mother
so much that when she climbed in or out of bed he acted as her footstool.

SHE

Hollowed perfection of titans betrothed
the pregnant likeness of the splendid peaks,
colossus crowned citadels;
my skin bared
my back to rugged ground,
my knees
crimson rock cupolas
sentinel pillars at the cave's portal.
Eastward
my right arm urges
the morning vapor to disperse.
Westward at dusk,
my left arm subdues
the tapering candles.

Into my mouth I placed
one grape and another grape,
Sweetness flows within me.
My infant his mouth pursed
the nipple yielding
milk
streaming within him ripples quivering.
The froth enchants his wrath into dream.
From the eager full licks
arise within me
the rare fluids
running
rivers through the fat earth.

Even while the baby clasps
to my bosom
there pass through my thighs upright
hosts of tribes
infantry and cavalry
majestic in their garb and callous,

who relinquish at the mouth of my cave
the plunder of their wars
gifts and vows,
rare animals, choice fragrances
woven tapestries, slaves for bondage
the taste of condiments,
lapidary breastplates,
the writings of forgotten nations
into me tumble and are interred
they, together with their loot.

Unsatiated is my murmuring lust
in its innermost lairs,
the spaces of content, the pool
where the stormy liquids gush,
exchanging measure for form
changing lava to the extract of the vine,
ambrosia into milk
and the conjugal semen to blood.

Exacting veneration she commands,
I am the crucible and its source
forged within me
secrets
ores, tempered and cooled.
My children arise and confirm,
bow and prostrate themselves in awe
for my endowment to the suckling infants,
and my blessing
to the soldiers' promenade—
They, who depart me
with cheering exultation,
make their way back,
humbly yearning to return.
—Nira Shamir

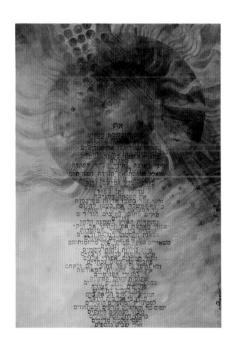

SHE
POEM BY NIRA SHAMIR
ILLUSTRATIONS BY NIRA AND AMI SHAMIR

Illustrated Hebrew poem; English translation by Professor Shalom Carmy

The poet emphasizes the archetypical and metaphoric aspects of womanhood, additionally reminding us of the feminine aspect of God and Judaism.

MANY DAUGHTERS

HAVE DONE VALIANTLY,

BUT YOU SURPASS THEM ALL.

רבות בנות עשו חיל

ואת עלית על־כלנה:

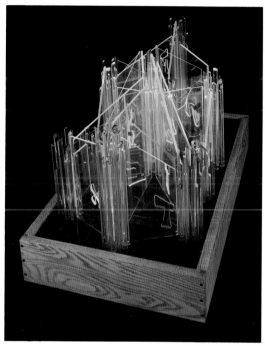

LIFE SOURCE, SANDI KNELL TAMNY

Construction
Plexiglas, wood, and electronics
28" x 25 3/4" x 43 3/4"

The artist relates the 22 lines in the Aishet Hayil to the 22 paths inter-con-necting the ten Sefirot on the Tree of Life in the Kabbalah. The clusters of rods contain ten images of herself, surrounded by 59 images of women who have touched her life.

Grace is deceitful

and beauty vain,

a woman who fears God,

she should be praised.

שקר החן והבל היפי

אשה יראת־ה׳ היא תתהלל׃

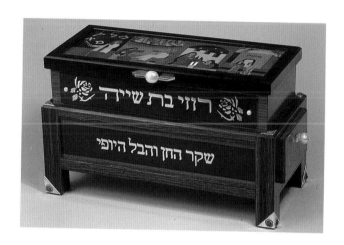

JEWELRY BOX, LORELEI AND ALEX GRUSS

Cocobolo and ebony wood; glass mirror
Inlay: silver; abalone shell, mother of pearl, antique and pink ivory, purpleheart,
yellow ossage, padauk and bloodwood
Settings: rose diamonds, cabochon rubies and emeralds, South Sea natural pearls
13" x 6" x 8"

Inscribed in Hebrew: "Ruzi, daughter of Shiya. Grace is deceitful and beauty
vain; a woman who fears God, she shall be praised."

Portrayed on the lid are four mitzvot performed by women: lighting the Sabbath
candles, family purity, charity, and education of the young.

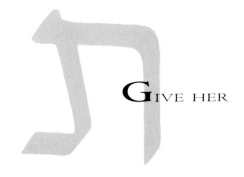

G<small>IVE HER</small>

B<small>UT THE FRUIT</small>

O<small>F HER HANDS</small>,

תנו־לה מפרי ידיה

THE THREADS THAT BIND US - EARTH ELEGIES
DENNIS PAUL / LYNN SMALL

Mixed media
102" x 88" x 96"

This photo illustration is a symbolic representation of the site-specific installation, incorporating elements from Julia Keiner Forchheimer's life and philosophy

AND LET HER BE PRAISED

IN THE GATES

ויהללוה בשערים

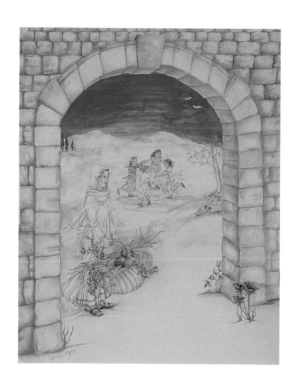

PAINTING, CHANA GALITZER

Watercolor on paper

22 1/2" x 29"

By her

own deeds.

מַעֲשֶׂיהָ׃

BARUCH SHE-ASANI ISHAH, ARONA REINER

Sculpture: oil and collage on plastic
56" x 27" x 34"

English translation: Blessed is He who made me a woman. Woman is portrayed from Eve's eating an apple to the pains of childbirth, to motherhood, creativity, knowledge, beauty, nature, and Time. This Israeli artist defines one of the meanings of Aishet Hayil as woman soldier — hence the army insignia on the collar.

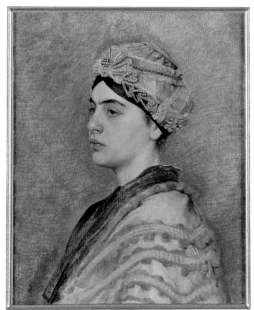

THE JEWISH BRIDE, ISIDOR KAUFMANN
1854-1921

Oil on canvas
22" x 20"

Private Collection

"SHE SEEKS OUT WOOL AND LINEN, AND HER HANDS WORK WILLINGLY."

Julia Keiner Forchheimer, born in 1900 and living to the age of 91, was a child of this century. She embodied an old world modesty and a modern artistic sense, both of which found expression in the weaving which she made her lifelong career. We learned a great deal from her, and one could say that as well as well as being our patron, Julia was also our muse.

In Wilhermsdorf, Germany, where Julia was born to a traditional family — her father a businessman, and her mother a housewife — the dedication of such a self reliant young woman to her artistic career must have seemed a bolt from the blue. She worked regularly on a loom in her uncle and aunt's house until 1927 when, at the age of 27 she attended the Kunst und Kunstgewerbeschule (Arts and Crafts Institute) and set up her own studio in Frankfurt. According to those who knew her Julia kept her own counsel: the value she put on an object was based on her criteria, not the values of others. She persevered in her work until 1936 when the political climate of Germany made anything but flight impossible.

Julia's emigration to Palestine saw the beginning of a wonderful marriage of Julia's hard work and search for artistic growth with the needs and optimism of the nascent Jewish state. Israel was itself like a raw material; the time was ripe for the new land and its scenery to inspire new forms. Julia soon made a name for herself at the Bezalel Institute, which had in those years completely revitalized itself in emulation of the Bauhaus aesthetics of her native Germany. Her artwork represented Israel in exhibitions in Milan and Munich. The United Nations commissioned curtains from her in 1952, and later Hebrew Union College commissioned a wall covering for their synagogue.

While at Bezalel Julia also won numerous awards as a teacher, and inspired many of her students to pursue artistic careers of their own. She was of the philosophy "that by my students I'll be taught." Weaving requires patience, and strength, and in Julia's opinion a sense of

experiment. She encouraged a respect for materials, for letting the natural colors and textures and proportions of the yarn dictate the structure of the final pieces. She also felt that a design ought to reflect the needs of modern life, searching as she was for "a new form which is not based on ornament developed by earlier civilizations," and that the discovery of these new forms lay in the diligence of the act of weaving itself.

Just as a weaver must respect the space each row of material requires — too tight and the piece will warp, too loose and it will cave in — Julia had a sense of openness in her home, which was simply decorated and free of ostentation, and in her relationships with others, which were always direct and honest. While she might find little allure in a fancy jewel, she could find wonder in a simple object for its natural beauty. Her home was decorated with the shells and rocks which she collected. She did not place a value on the things around her, she treasured them. And if she eschewed a certain public life, it was because she found little time or interest in being praised on a dais by the numerous charitable causes to which she contributed.

Julia was also before her time in her concern for environmental issues, and the warm earth tones of her works reflect her respect for organic materials. Her personal warmth was manifested in the fact that no one could find a better friend. She always asked what she could do for others, expecting little in return.

At the age of 64, and again against popular practice, Julia married her cousin, Leo Forchheimer and settled with him in New York. She continued her work in America, designing fabrics for such houses as Knoll and Isabel Stuart. Many years later, when she was physically unable to operate her loom, she still managed to pursue her art by cutting swatches of material from previous weavings and using them in collage. These she gave to friends and family.

We would like to think that Julia would approve of the fact that rather than erecting a memorial, we have created an exhibition which affords other women artists the opportunity to express themselves. Having her as the keystone of this project seems more subtle, more "Julia." We are proud to acknowledge that all of the work in this gallery is an offering to the Aishet Hayil, a woman through whose deeds life is made sacred and beautiful.

Sarah L. Schmerler
Exhibition Coordinator

THE ARTISTS

ITA ABER is an artist, curator, and historian who lives in Yonkers, NY. She has studied needlework at the Valentine Museum in Richmond, VA, and received her B.A. in cultural studies from Empire State College. Her work is in many collections including the Skirball Museum in Los Angeles and the Cooper Hewitt Museum in New York.

JERILYNN BABROFF has studied at SUNY Purchase, and under Peter Voulkas and Betty Woodman. She has been working in clay for 20 years, and has exhibited widely in the U.S. and abroad.

BAT ZVI studied at the Avni Institute in Tel Aviv. After her military service she became a fashion designer in Israel; she has also lived in Africa. Her tapestries have been exhibited extensively in the U.S. and abroad.

SIRI BERG has had numerous solo and group exhibitions in New York City and Stockholm, including one at the Yeshiva University Museum. Her work is in many collections, including the Solomon R. Guggenheim Museum, The Jewish Museum, the New York University Gray Art Gallery, and the Israel Museum.

RIVKAH TEITZ BLAU has a doctorate in English literature from Columbia University, and is the Principal of Shevach High School in Queens, NY. Elisheva Rabinovitz Teitz is a graduate of Stern College for Women of Yeshiva University and has a Masters degree in Hebrew literature from New York University. She is currently an instructor of Tanach at Bruriah High School in Elizabeth, New Jersey.

MALKA COHAVI received her B.F.A. from the Bezalel Academy of Arts and Design in Jerusalem, where she currently teaches jewelry design and silversmithing. Her work has been exhibited internationally in Vienna, Prague, and Basel. Since 1976 she has been associated with D.H. Gumpel, the preeminent silversmith in Israel, and upon his demise she became the owner and designer of the firm.

CHANA CROMER was born in Italy and educated in the U.S., where she received an M.A. in education from Boston College, and a B.A. in literature from Washington University in St. Louis. She currently resides in Jerusalem, where she has taught design at Hadassah Community College. Her work can be found in the collections of the Wolfson Museum and the Wexner Foundation in Jerusalem.

MENUCHAH DEUTSCH lives and works in Jerusalem, and was one of the leading students of Julia Keiner Forchheimer.

ELLEN EICHEL received her M.F.A. from Pratt Institute and resides in New York City. She currently teaches textile design at Georgian Court College in New Jersey, and gives workshops at Danger Island Studio in Ketchikan, Alaska. Her work has been exhibited at Princeton University and the National Arts Club.

MARTIN AND JOAN BENJAMIN-FARREN have collaborated as artists since meeting at the University of Iowa campus in 1969. While there, Joan received a Masters degree in art, and Martin a Ph.D. in music. Their works have been exhibited in the Yeshiva University Museum and across the U.S., and are in important collections including such major museums as the Wolfson Museum in Jerusalem and the Skirball Museum in Los Angeles.

CHANA GALITZER is a watercolorist who lives and works in Jersualem.

SUSAN GARSON AND TOM PAKELE live and work in Boulder, Colorado. They met at UCLA where they both received their M.F.A. degrees, and have collaborated since 1984. Their work can currently be seen in a two-person show at the Kohler Art Center in Sheboygan, WI.

MARION GREBOW received her B.F.A. from Cooper Union in New York, and has had numerous exhibitions in the U.S. and abroad. Working with porcelain for 20 years, she has a studio in West Redding, CT, where she creates tile murals and Juadaica.

LAURIE GROSS received her Teacher's Credential in elementary education from the University of California, Berkeley, and a B.F.A. in textiles from the California College of Arts and Crafts. Her work can be found in the collections of the Skirball Museum in Los Angeles, the Wolfson Museum in Jerusalem, and the Pucker Safrai Gallery in Boston. She has had exhibitions of her weaving at the Jewish Museum of San Francisco, and the Yeshiva University Museum.

LORELEI GRUSS was born in Manhattan, emigrating to Israel at the age of ten. At 15 she began working as an apprentice for various crafts people in Jerusalem, developing her skills in woodworking and silversmithing. They met in Israel and have collaborated ever since.

ALEX GRUSS was born in Buenos Aires and emigrated to Israel at the age of 15. He has worked as a graphic and stage designer for Israeli television, and as a cartoonist and illustrator for publications in Israel and the U.S. They currently have a solo show at Yeshiva University Museum.

ESTER JESSELSON is a graduate of Beit Chinuch in Sao Paulo, Brazil. When she first came to New York in 1988 she was inspired by Pauline Fischer to try her hand at needlework, and she has since produced numerous ceremonial and ornamental works.

TOVA KATZ is a gifted nine year old artist who attends the Maimonides Day School in Brookline, MA.

JANE LOGEMANN, who received her B.A. from the University of Wisconsin, lives in New York City and has exhibited extensively both in the U.S. and abroad. She has produced a number of books as well as videos, and her work can be found in collections which include the Museum of Modern Art, the Solomon R. Guggenheim Museum, and the Jewish Museum.

JUDITH COHEN MARGOLIS received her M.F.A. from the University of Southern California, and has taught painting and drawing at UCLA, The University of Judaism in Los Angeles, and the Brandeis-Bardin College Institute. Her work is in many public and private collections, including the Hebrew Union College Skirball Museum in Los Angeles.

SHARON NORRY received her B.F.A. from the School for American Craftsmen in Rochester, NY. She has been weaving for 23 years, and her work is in such public collections as the Skirball Museum in Los Angeles and the National Museum of American Jewish History in Philadelphia. Her ceremonial textiles have been commissioned by numerous synagogues across the U.S..

DENNIS PAUL AND LYNN SMALL have lived and worked in Europe and Mexico, and currently reside in Los Angeles. Dennis received his B.A. from City College, New York, and continued his studies at City University, New York in Psychology; Lynn is a graduate of the High School of Music and Art, and

received her B.F. in arts and arts education from New York University. They began collaborating in 1978 during a residency fellowship program at Yaddo in Saratoga Springs, NY, and have since been the recipients of various grants and awards, exhibiting extensively in the U.S. and abroad.

ELAINE PERLOV studied Japanese art history at Amherst College and has lived in Japan. She resides in the Boston area where she designs a line of hats called "Immortal Coil." She has both worked and shown at the Museum of Fine Arts, Boston, and her hats have been featured at the Henri Bendel stores.

ARONA REINER has studied at Parsons School of Design, the Art Student's League in New York, and the Bezalel Academy in Israel. She lives in Israel, and her work has been exhibited extensively there and in the U.S., including the Yeshiva University Museum.

GABI SALZBERGER is a Jerusalem artist who works with photographic images. She received her B.F.A. from the School of Visual Arts in New York, and has exhibited in group shows at the Israel Museum and Sara Conforty Gallery, Tel-Aviv.

NOEMI SAREL has a studio in Jerusalem, where she creates multi-media sculptures on ceramic forms. Inspired by Jerusalem folklore, she has exhibited in many one-woman shows.

SUSAN SCHWALB received her B.F.A. from Carnegie-Mellon University. She has had many exhibitions nationally, including solo shows at the B'nai B'rith Klutznick Museum in Washington, D.C. and at Yeshiva University Museum.

JANET SHAFNER received an M.A. in studio art from Connecticut College, and a B.A. in art history from Barnard College. She has been the Director of the Adult Art Program at the Lyman Allyn Museum, and has taught extensively. Her many exhibitions include a solo show at the Yeshiva University Museum, and her work can be found in such collections as the Housatonic Museum in Bridgeport, CT and the Museum of Fine Arts in Springfield, MA.

AMI SHAMIR is an internationally known artist and sculptor whose major installations can be seen at the Museum of Tolerance/Simon Wiesenthal Center for Holocaust Studies in Los Angeles, John F. Kennedy International Airport in New York, and the Cardozo School of Law. He has also designed costumes and sets for repertory and commercial theaters in Israel.

NIRA SHAMIR was born in Israel and received her B.F.A. from Midrasha College; she was a teacher of art and art history in Tel Aviv schools. Her poetry has appeared in various publications in Israel.

CORINNE SOIKIN STRAUSS studied at the High School of Music and Art, Pratt Institute, and the Art Students League in New York. Her work has been shown in a variety of exhibitions in the Northeast, including a one-person show at the Yeshiva University Museum, and she has fulfilled commissions for the Skirball Museum in Cincinnati. She currently resides in Croton-on-Hudson, NY.

SANDI KNELL TAMNY received her B.F.A. from Kent State University and has had many exhibitions in Ohio, where she resides, as well as in New York.

CHAGIT ZELCER studied art and graphic design at the School of Visual Arts, and also worked in New York City as a freelance graphics artist before making aliya to Israel. She lives and works in the Golan Heights in northern Israel, where she creates ceremonial and decorative objects in embroidery and applique.

CREDITS

Sylvia A. Herskowitz, Curator

Sarah L. Schmerler, Coordinator

Ariel Braun, Coordinator of art from Israel

Robert Becker, Designer, Contemporary Gallery

Deborah Reiser, Designer, Prelude Gallery

Catarina Tsang, Assistant to Ms. Reiser

Jeff Serwatien, Installation

Ava Barber, Catalogue Design

Allen Rokach, Photographer

We wish to express our appreciation for the ongoing assistance given by our University colleagues: Randi Glickberg, Gabriel Goldstein and Bonnie-Dara Michaels of the Museum; Norman Goldberg, Gary Mann, and Roman Royzengurt, Photographic Services; Zalman Alpert, Zvi Erenyi, and Haya Gordin of the Mendel Gottesman Library; the entire staff of the Department of Facilities Management

This exhibition would not have become a reality without the advice, guidance, and assistance of our founder, Erica Jesselson, Chairman of the Museum Board of Governors, and her husband, Ludwig Jesselson, obm.

We also acknowledge the counsel of Mr. Joseph Levine, Esq., Mr. and Mrs. Rudolph Forchheimer, Mr. and Mrs. Paul Forchheimer, and especially Mrs. Greta Kaufman.